CREATIVE LETTERING
COMPANION

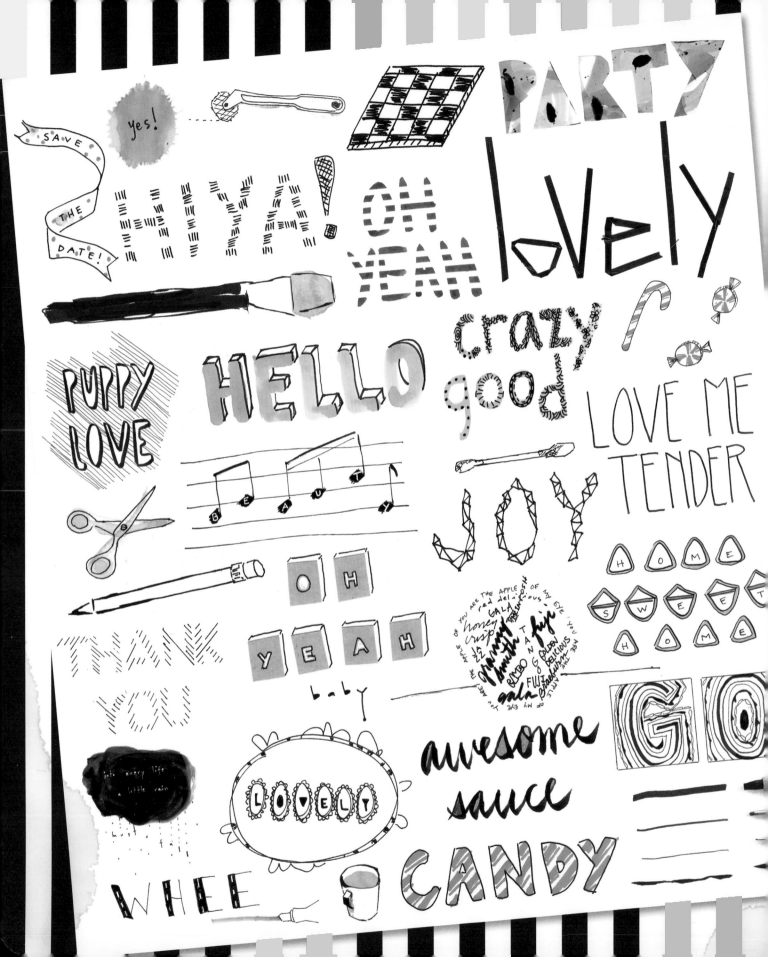

CREATIVE LETTERING
COMPANION

More than 40 Imaginative & Inventive Prompts

Jenny Doh

LARK
New York

New York

An Imprint of Sterling Publishing Co., Inc.
1166 Avenue of the Americas
New York, NY 10036

ISBN 978-1-4547-1069-1

Distributed in Canada by Sterling Publishing Co., Inc.
c/o Canadian Manda Group, 664 Annette Street
Toronto, Ontario M6S 2C8, Canada
Distributed in the United Kingdom by GMC Distribution Services
Castle Place, 166 High Street, Lewes, East Sussex BN7 1XU, England
Distributed in Australia by NewSouth Books
45 Beach Street, Coogee, NSW 2034, Australia

For information about custom editions, special sales, and premium and corporate purchases, please contact
Sterling Special Sales at 800-805-5489 or specialsales@sterlingpublishing.com.

Manufactured in China

2 4 6 8 10 9 7 5 3 1

larkcrafts.com
sterlingpublishing.com

CONTENTS

INTRODUCTION

Welcome to *Creative Lettering Companion*! Sister books *Creative Lettering*, *More Creative Lettering*, and *Creative Lettering for Kids* introduced inventive lettering techniques that walked you through the here-to-stay trend of artful lettering. I'm thrilled to now give you a hands-on workbook for continuing your practice. This workbook will walk you through even more hand-lettering techniques and ideas, but best of all, it includes plenty of space for you to try those techniques—right on the pages! Practicing on the pages will allow you to really make this workbook your own, play with and perfect the techniques, and have a lifelong idea journal for a poster, card, or one of countless other projects using the techniques in this book. The more you embrace the beautiful messiness of practice, the more this book will transition from pristine to deeply loved . . . a practicing ground, if you will. You are invited to get messy and experimental so that when you're ready to make that sign or poster or card, you can buy high-quality paper and do your thing.

NOW HEAR THIS!

For some of the prompts and techniques presented in this book, the pages will become affected when you practice on them. For example, using watercolor paints as suggested may make the pages buckle or wrinkle slightly. But that's okay! That just means you're using this workbook to its full potential. To accommodate this practice approach, the pages with prompts using liquids or other tools that may alter the pages (e.g., staples) have a buffer page on the back side, so you won't have to worry about the effect these tools and materials may have on subsequent prompts.

Rather than keep the pages crisp and perfect, have fun playing and experimenting as you continue to hone your creative lettering style. If you would prefer to keep the pages of this book in newer condition, it is recommended that you use separate pieces of scratch paper to practice prompts that involve liquids.

BASICS

The beauty of creative lettering is that you don't need much in the way of tools to produce beautiful works of art. A simple pen and paper will often do the job! But there's also fun in knowing that you can experiment with a wide range of tools and materials to create your lettering projects. Here are a few items to have handy, both for the projects in this book and your own lettering experiments.

TOOLS & MATERIALS

Permanent markers will be your constant companion as you work through the projects in this book. They resist bleeding when they interact with water, making them a great option for lettering projects that you'd like to last forever; letters drawn with permanent markers won't bleed, fade, or become distorted over time.

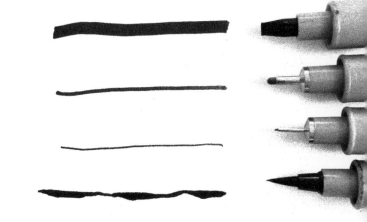

Permanent markers come with tips in a wide variety of widths and styles, from extra fine and fine to wide, chisel, or brush. Some of the projects will specify that a certain width may work best, but trying each type of marker out for personal preference is also a great idea. Extra-fine and fine permanent markers will make very thin lines, which is ideal for drawing small letters or outlining bigger letters. The very widest ones would be ideal for drawing large letters on a poster.

Chisel-tip permanent markers have angled tips that are also available in multiple widths. The angled tip allows you to create broad, medium, or fine strokes all with one marker, depending on how you hold it. Writing with the marker when the widest part of the chisel tip is horizontal to the paper makes a broad stroke, whereas holding the marker when the widest part of the chisel tip is vertical makes medium strokes. Using just the point of the chisel tip makes a fine stroke. If you're working on a project in which you want all fine lines, a chisel tip doesn't allow for the same kind of control that an extra-fine-width marker would, but the chisel tip does allow you more options within one tool.

Brush-tip permanent markers have a very soft tip, which allows you to use them almost like a paintbrush. Just as with a paintbrush, using light pressure will create a thin line, and using heavy pressure will create a thicker line. Brush-tip permanent markers are great options for lettering projects that feature downstrokes and upstrokes, as it's easy to adjust the pressure depending on the direction of the letter stroke.

Permanent markers come in many colors, but the projects in this book typically suggest using black permanent markers so color can then be added with watercolor paints, acrylic paints, or the like.

Sumi ink is a permanent black ink that is ideal for lettering. It comes in a bottle and is liquid-based, so you also need a **lettering brush**. To use sumi ink, dip the brush into the ink and then use it just as you would a paintbrush or a brush-tip marker to create letters. If you don't have sumi ink and/or a lettering brush, you can easily use brush-tip markers or another type of paint with any type of paintbrush for a similar effect.

Watercolor paint and **acrylic paint** are excellent options for adding color in the background or the actual letters. When using either type of paint, you will also need **paintbrushes** and a **container of water**. **Watercolor pencils** are a great alternative to watercolor paint, as they provide the look of watercolor paints but with a little more control than a paintbrush would provide. To use watercolor pencils, add color with the pencils first, then use a clean, slightly wet paintbrush to add water directly onto the colored portions of the letter. You can add the water to the entire colored portion or just the edges for different effects.

Keep in mind that when using sumi ink, watercolor or acrylic paints, or watercolor pencils with water, it will be important to let the page you're working on dry before proceeding to the next project. This will prevent the pages from sticking together or the colors from mixing in ways you don't intend.

Gel pens, **colored markers**, and **highlighters** are also great tools for adding color to lettering projects. Each one will have different levels of opacity, from darker, bolder markers to very subtle highlighters, so keep that in mind when choosing your method of adding color. Oftentimes, adding color can be carried out in a variety of ways, so if the project suggests acrylic paint but you'd rather use colored markers, go for it! This workbook is the perfect place to try out different tools and materials.

For any prompt that involves markers or paint, some people like to use a **No. 2 pencil** with an eraser to lightly sketch or practice a word before going over the pencil with the final medium. Though in no way required, this can be helpful. A few of the prompts suggest using the eraser end of a No. 2 pencil to create dots or letters, so this is a good tool to have on hand either way.

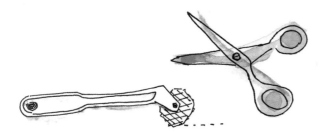

In addition to writing and coloring utensils, other supplies you will see suggested in the prompts in this workbook include **scissors**, **artist's tape** or **washi tape**, a **stapler**, a **tracing wheel**, a **straight-edge ruler** and a **square acrylic ruler**, **letter stencils** and a **stencil ruler**, and a **glue stick**. Some of the projects presented here create letters, backgrounds, and textures in nontraditional ways, so **Bubble Wrap®**, **painter's tape**, **coffee**, **cotton swabs**, and **string** or **thread** are also materials you will see suggested for use.

ALL ABOUT PAPER

As you embark on the projects in this book, have fun using and loving its pages. If you'd like to make a card, poster, or the like with the techniques you have learned for special projects, here are some good options for various types of paper to use.

Watercolor paper, though more expensive than traditional white printer paper, is a fabulous option. It comes in a variety of styles, including rough, cold-pressed, and hot-pressed (the smoothest of the options), as well as in a variety of "weights" (or thicknesses). Both markers and paint will perform

beautifully on watercolor paper. **Poster board** is also a fun option depending on your project, though if you use too much watercolor or acrylic paint and the poster board becomes too wet, it may buckle. Use a light hand with paint if you're planning on using poster board. **Kraft paper** and **cardstock** are also good options if you'd like a sturdier paper choice than printer paper but don't have access to watercolor paper.

LETTERING TERMS

The world of hand lettering comes with its own lingo. Here are two words with which to familiarize yourself.

A **downstroke** is a stroke created by moving a pen from the top of the letter to the bottom, using more pressure so it's thicker than other parts of the letter. An **upstroke** is created by moving the pen from the bottom of the letter to the top, using less pressure so it's thinner than other parts of the letter.

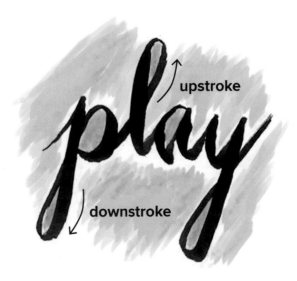

upstroke

downstroke

LETTERS WITH WATERCOLORS

PROMPT: Draw freehand horizontal lines on paper with a black permanent marker. Make uppercase block letters within those lines with a black fine-point permanent marker. Add washes of watercolors to the spaces in between the letters, leaving some spaces blank.

HOW COOL IS THAT?

HOW COOL IS THAT?

HOW COOL IS THAT?

TRY IT!

Practice on the opposite page and then make your own lines and letters on this page. Be sure to let this page dry after you've created your letters with paint, as this will prevent the pages from sticking together.

WHAT YOU'LL NEED

- Black permanent markers in assorted thicknesses
- Watercolor paints
- Paintbrush
- Container of water

MITERED LETTERS

PROMPT: If you're a carpenter or a traditional quilt maker, you probably have experience cutting wood or folding fabric so that the corners of two items are cut at a 45-degree angle and joined together. Create that same mitered effect on letters by making a diagonal line wherever you see a 90-degree angle.

There's more than one way to miter a letter. For example, for the letter L, you can make a mitered diagonal at three different spots. You can choose to do all three or just two or just one. The top miter can start from the right corner or the left corner, which affects the direction of the diagonal. Same goes for the other two spots.

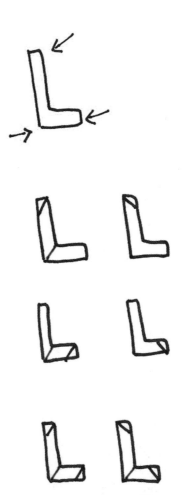

For letters that have spots with two right angles close to each other, like the letter I, make one diagonal or a V with two diagonals. Add a long line starting from the diagonal lines to introduce more interest if you like.

The letter O can be left alone with no mitering, or you can give it a bit of unexpected variation to add personality to your text. For other letters with curves, either leave them unmitered or splice them into smaller segments and miter each section.

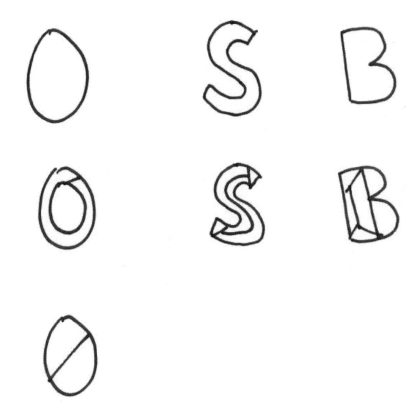

TRY IT!

Now it's your turn. After you practice mitering letters on all of the preceding pages, make your very own from start to finish right here on this page. Go on . . . it's only paper!

WHAT YOU'LL NEED

- Any writing instrument of your choice!

HIGHLIGHTED & DOODLED

PROMPT: Make letters with one or two colored highlighters. With a permanent black marker, doodle on top of the highlighted letters using straight lines, curved lines, small teardrops, dots, flowers, and more. Make sure to stay within each letter shape for the full highlighted effect.

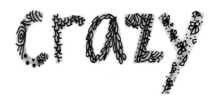

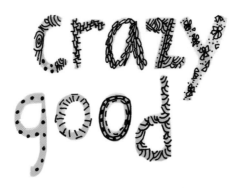

 If you get stuck coming up with doodle ideas, look around and find pattern inspiration on fabric, wallpaper, signs, and packaging.

TRY IT!

Highlighters come in many fun colors. Gather your favorite colors and make your highlighted and doodled letters here.

WHAT YOU'LL NEED

- Highlighters in assorted colors
- Black permanent marker

bye

STRONG COFFEE LETTERS

PROMPT: Make a cup of very strong dark coffee. Dip the eraser end of a pencil into the coffee and create letters. Write at an angle to make cursive letters or perpendicularly to make block letters. For another variation, make shapes, like ovals, and then write letters inside those ovals with a black fine-point permanent marker. Outline and embellish all of the coffee letters and shapes with the black marker.

TRY IT!

Got your coffee? Let's do it! (Please note that the following page is not a buffer page because you don't need to use very much coffee on the eraser to make your marks. As long as you use a light touch, any buckling of the page should be very slight, if at all. Make sure that the marks are dry before turning the page or closing the book.)

WHAT YOU'LL NEED

- Cup of very strong dark coffee
- Pencil with an eraser
- Black fine-point permanent marker

PROMPT: Make more fun coffee marks by dipping the eraser end of a pencil into the coffee and stamping it onto paper, or really let loose and just scoop some coffee into a spoon and splatter it! Then embellish each circle or splatter with the black fine-point permanent marker.

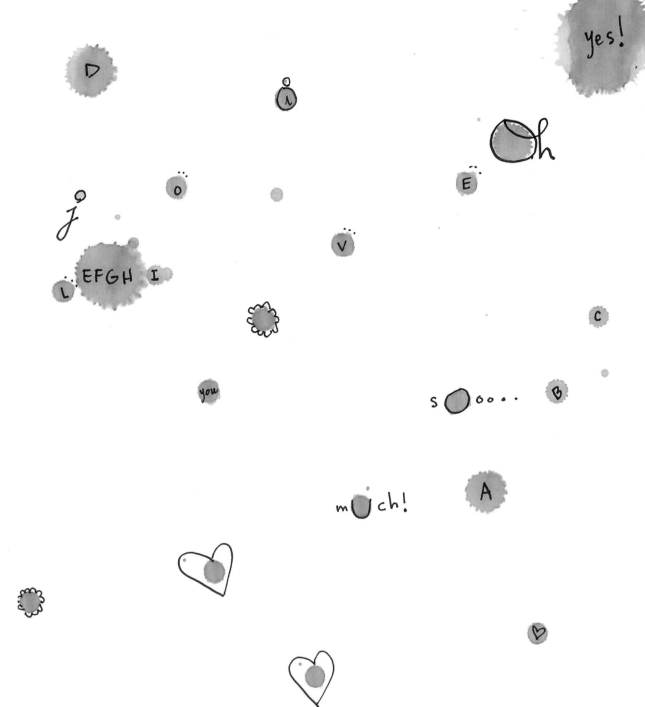

TRY IT!

Drip or stamp your own coffee stains here and then use a black fine-point permanent marker to make letters, embellishments, and words in response to the marks. Let the marks be your inspiration. Please make sure that the marks are dry before turning the page or closing the book.

No need to press down hard with the coffee-loaded eraser. Just a very light touch is all you need to transfer the coffee from the eraser to the paper.

COTTON-SWABBED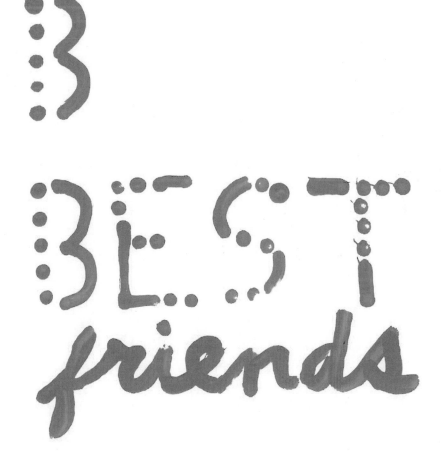

PROMPT: Dip a cotton swab in acrylic paint. Make dots and lines with the swab and create a word out of block letters. Next, make a second word with the same swab and paint using cursive letters. Re-dip the swab in the paint as needed.

 When making dots, you don't need very much paint on the swab. When making cursive letters, you'll need to load slightly more.

TRY IT!

Practice both block and cursive letters with a cotton swab and acrylic paint here. Allow the paint to dry on these pages before turning the page or closing the book.

WHAT YOU'LL NEED

- Cotton swab
- Acrylic paint

 Try incorporating different colors of acrylic paint in unexpected ways. For example, if you are writing BEST FRIENDS, make the word BEST with red paint and FRIENDS with blue paint. If you are writing the word BOY, make the B with blue paint and OY with orange paint.

FASCINATING FACETS

PROMPT: Make a cluster of dots in the shape of your letters using a black permanent marker. Alternatively, you could lightly sketch the letter with a pencil and then surround the sketch with a cluster of dots. Connect the dots with the marker in a random manner to create facets in assorted sizes. Make dots at the connecting points using a slightly thicker black marker. Erase pencil marks as needed.

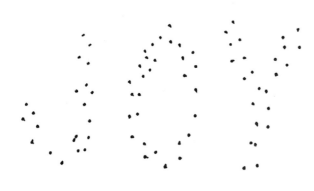

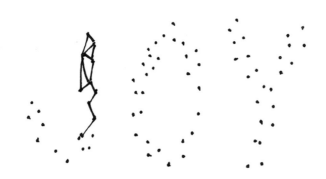

With markers or watercolors, add pops of color to all or just a few of the facets.

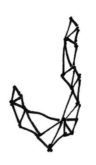

TRY IT!

Look. Here's a single dot. Add a few more and practice your first faceted letter here.

WHAT YOU'LL NEED

- Black permanent markers with assorted tips and thicknesses
- Pencil (optional)
- Eraser (optional)

DOT ... TO ... DOT

PROMPT: Envision the letter you want to stamp with dots. Dip the eraser of a pencil into acrylic paint and stamp dots that form the basic structure of the letter. For example, to stamp the letter N, make four dots for the structure and then stamp additional dots in between the structure dots to complete the letter. Re-dip the eraser into the paint as needed.

TRY IT!

After you stamp your letters here, allow the paint to dry for a couple of minutes before you turn the page or close the book.

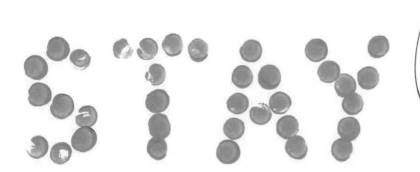

WHAT YOU'LL NEED

- Pencil with eraser
- Acrylic paint

MASKED

PROMPT: Cut or tear several short strips of ¼-inch-wide (6 mm) painter's tape and tape them horizontally onto the page, leaving approximately ¼ inch (6 mm) between each strip. Write letters directly over the rows of tape using a lettering brush and Sumi ink. Let the ink dry and then peel off the tape to reveal the letters.

TRY IT!

Using painter's tape will allow you to peel the strips off with ease after you practice lettering on this page.

 Sumi ink is a permanent black ink that is ideal for lettering. If you don't have Sumi ink and a lettering brush, use markers or another type of paint with any type of brush.

WHAT YOU'LL NEED

- Blue painter's tape, ¼ inch wide (6 mm)
- Scissors (optional)
- Lettering brush
- Sumi ink

MUSICAL

PROMPT: Draw five stacked horizontal lines with a black fine-point permanent marker. This will be the musical staff. Make a scribbly dot on the staff either on one of the lines or one of the spaces between the lines. Make vertical lines on the right sides of the scribbly dots. These will be the musical notes. Connect two or three of the notes with single or double lines. Add a squiggly tail for singular notes. With a white gel pen, write small uppercase letters in each of the notes.

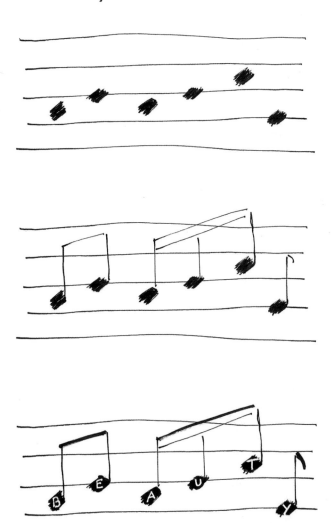

TRY IT!

Don't worry about making the musical staff or the musical notes perfect. Slightly crooked lines are good.

TIP

Take a look at sheet music to get ideas for additional symbols to add.

WHAT YOU'LL NEED

• Black fine-point permanent marker
• White gel pen

TIP

Make two sets of musical staffs (one to represent the treble clef notes and one to represent the bass clef notes). Write a word on each staff and make the stems of the notes on the bottom staff point downward, like the notes found on the bass clef.

TREBLE CLEF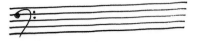

BASS CLEF

CAMEO APPEARANCE

PROMPT: With a black fine-point permanent marker, doodle overlapping double ovals for each letter of a word. Fill in the spaces between the double ovals with the black marker to create stripes. Add small scallops around each oval and color in some of the scallops with the marker. Make block letters in each of the ovals, filling in some letter shapes (like A, B, D, M, O, P, R, U, V, W, and Y) completely with the black marker.

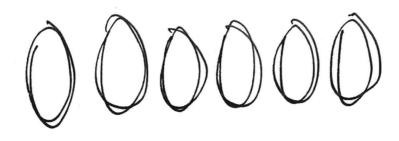

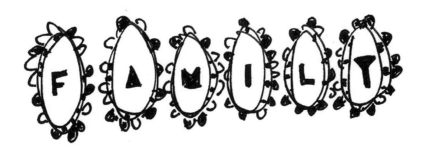

TRY IT!

Practice your cameo-lettered word here, and once you're done, make double ovals around the word. Fill the spaces between the double ovals to create black stripes and add scallops.

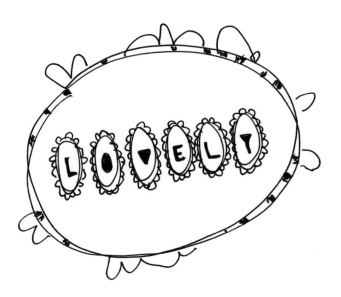

WHAT YOU'LL NEED

• Black fine-point permanent marker

PEPPERMINT CANDY STRIPES

PROMPT: With a black permanent marker, draw chunky block letters. With a red chisel-tip marker, make thick, slightly angled stripes inside each letter. Make thin red stripes in between the thick red stripes.

CANDY

CANDY

CANDY

CANDY

TRY IT!

Practice your sweet striped letters here and then use personalized candy-striped letters to make holiday cards, ornaments, and place cards.

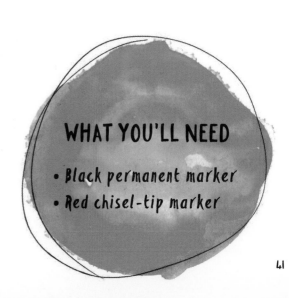

WHAT YOU'LL NEED

- Black permanent marker
- Red chisel-tip marker

CUT & PASTED

PROMPT: Fold a piece of black paper in half lengthwise, then in half again, lengthwise. Cut thin horizontal strips with scissors. Cut the strips into small squares. It's okay if the pieces are not exactly the same size. Adhere the small pieces of cut paper onto the page with a glue stick to form letters.

TRY IT!

Create a small word, or maybe your initials, out of black paper squares right here. If you don't have black paper, look through some of your junk mail to find colored papers that you can cut up.

WHAT YOU'LL NEED

- Black paper (or other colored paper)
- Scissors
- Glue stick (or other adhesive)

STAPLED STRIPS

PROMPT: *Fold a piece of black paper in half lengthwise, then in half again, lengthwise. Cut thin horizontal strips with scissors. Make letters with the strips by twisting and folding them as needed. Staple the letter strips onto the page, making sure to secure each twist and fold when necessary. Make sure you do this near the edges of the page so that the stapler can reach the paper strips.*

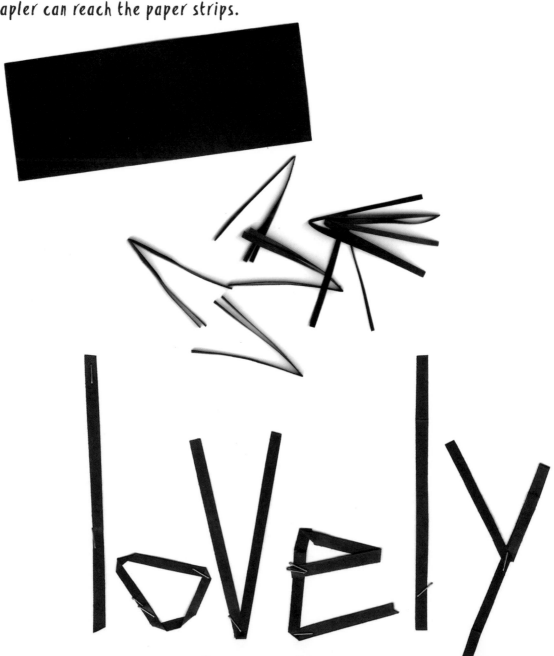

TRY IT!

After you cut your strips of paper, make them into letters and staple them here.

WHAT YOU'LL NEED

- Black paper (or other colored paper)
- Scissors
- Stapler with staples

BOTTOM-HEAVY & TOP-HEAVY

PROMPT: Draw a straight line using a ruler and pencil. Make a second horizontal line 1 inch (2.5 cm) below the first line. Make a third horizontal guideline ¼ inch (6 mm) above the second line. To make bottom-heavy letters, write "WELCOME BACK" (or different words, if you like) with block letters using a black permanent marker. The center segments of the letters should run along or end at the third guideline. Erase the pencil marks.

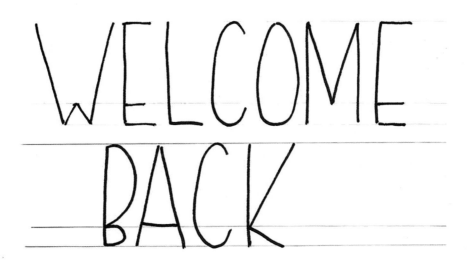

To make letters that are top-heavy rather than bottom-heavy, make the third guideline ¼ inch (6 mm) below the first line instead. Make the center segments of the letters run along or end at that third guideline.

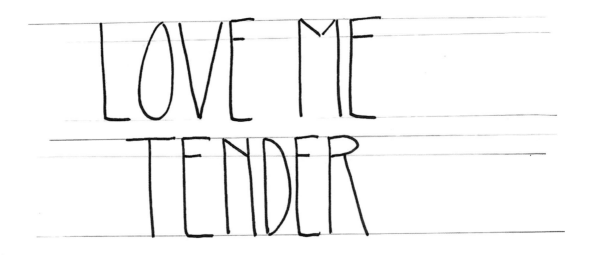

LOVE ME
TENDER

LOVE ME
TENDER

TRY IT!

Practice both bottom-heavy and top-heavy letters here.

Experiment with placing the guidelines in various places—directly in the middle of the first two lines, or even closer to the top or bottom line than they're shown here—to see which look you like the best.

WHAT YOU'LL NEED

- Ruler
- Pencil
- Black permanent marker
- Eraser

COLOR CLOUDS

PROMPT: Load a paintbrush with water and watercolor paint and make a small, imperfect color cloud. Rinse your brush and repeat with other colors. Let dry completely. Make block letter outlines over each of the color clouds with a black permanent marker. Add small lines within the outlined letters.

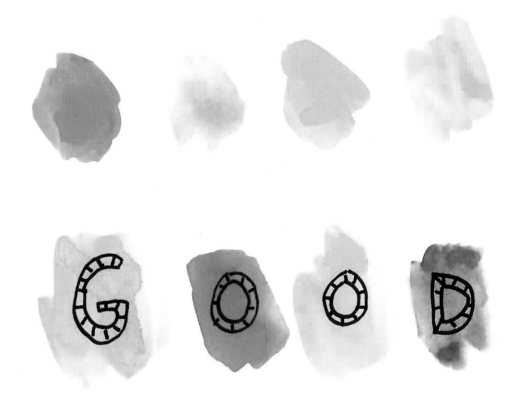

TRY IT!

Practice your color clouds here and allow them to dry before you turn the page or close the book.

 After you make the color clouds and lettering on this page, consider making more letters beneath the color clouds for visual interest.

WHAT YOU'LL NEED

• Watercolor paints
• Paintbrush
• Container of water
• Black permanent marker

BEAUTIFULLY BANNERED

PROMPT: All you need is a black fine-point permanent marker and some watercolor pencils to make these simple and beautiful lettered banners and garland.

LOVE ALWAYS & BYE: Draw simple banners by making two horizontal, parallel lines. Connect the points of the two lines on the left side by either making a straight vertical line or an inward-facing V shape with two diagonal lines. Draw another inward-facing V shape on the right side. Add lettering within the banners and beneath them. Color the banner with a watercolor pencil and blend the color with a wet brush.

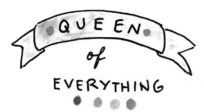

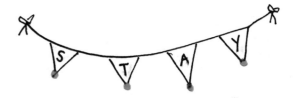

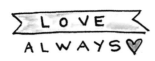

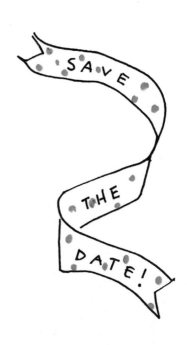

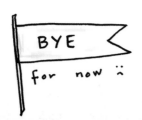

QUEEN OF EVERYTHING: Make a curved banner by drawing a rectangle that slightly curves downward on both sides. On the left side, add two short lines that continue to curve downward and connect the ends with a rotated inward-facing V shape. Repeat on the right side. Add lettering within the banner and beneath it. Color the banner with a watercolor pencil and blend the color with a wet brush. To make the dots, dip the watercolor pencil into water and then make a small dot. Repeat with different colors.

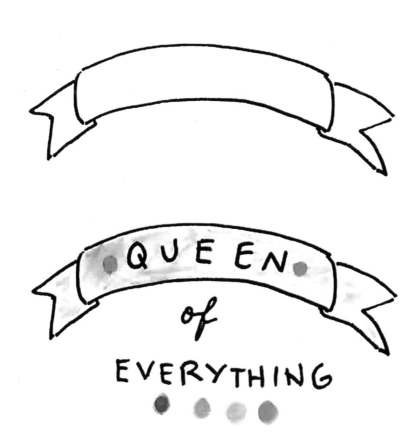

SAVE THE DATE: Make a wavy banner by drawing two parallel lines that curve downward and connect. To curve the banner along the way, connect the two parallel lines and then draw new parallel lines in the opposite direction. For a curve that's not quite as dramatic (like the example below), make a C-shaped line for the top of the banner, then draw a straight line on the left side and a line parallel to the first C-shaped line for the bottom of the banner. Connect the top and bottom parallel lines at each end of the banner with rotated, inward-facing V shapes. Add simple block lettering inside the banner. Dip a watercolor pencil into water and make small dots to decorate the banner.

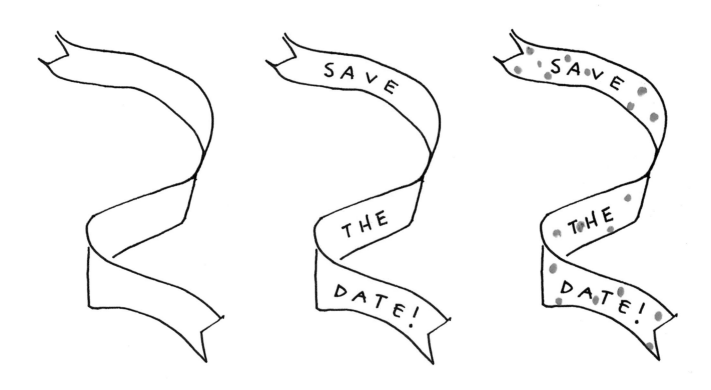

STAY: Make a simple garland by drawing small V shapes, one for each letter. Draw a curved line to connect the tops of the shapes and a bow at each end of the line. Add simple block lettering in each of the V shapes. Add color to the inside of the triangles with a watercolor pencil, blending with a wet brush to finish. Dip a watercolor pencil into water and make small dots at the bottom of each of the triangles.

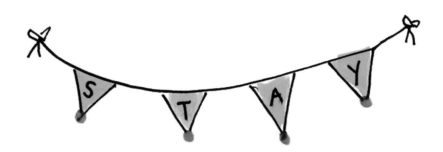

TRY IT!

Create your cute little lettered banners here. Of course, you can use your own special words, names, and messages to customize your work.

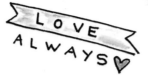

WHAT YOU'LL NEED

- Black fine-point permanent marker
- Watercolor pencils in assorted colors
- Small paintbrush
- Container of water

HIGHWAY ROAD

PROMPT: With a black fine-point permanent marker, draw block letters and create a rectangle out of one part of each letter to make the highway strip. Draw small rectangles within the strip. Fill in the negative space of the strip with the marker, leaving the small rectangles untouched. Negative space is the space around and between the subject, which in this case is the space around and between the small rectangles.

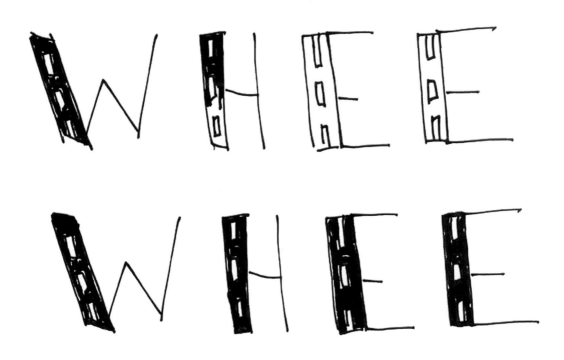

 For letters that have curves, consider making the entire shape a road with small rectangles inside it.

TRY IT!

Make your highway road letters here. And remember that you can take your time. It's not a race!

WHAT YOU'LL NEED

- Black fine-point permanent marker

STENCILED & COLORED

PROMPT: *Trace letters using a plastic stencil ruler and sharp pencil. Carefully add watercolors to the negative space around the edge of the traced letters. Let the paint dry completely and then erase the traced pencil marks.*

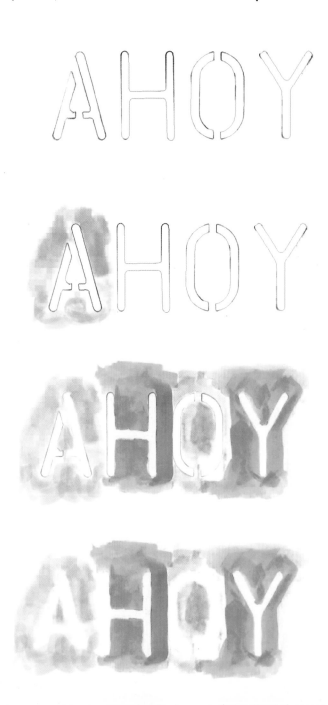

TRY IT!

Trace your letters here with your plastic stencil ruler. If you don't have watercolors, add color with markers or colored pencils. Allow the paint to dry on this page before turning the page or closing the book.

WHAT YOU'LL NEED

- Plastic stencil ruler (any size)
- Pencil with eraser
- Watercolor paints
- Paintbrush
- Container of water
- Colored pencils and markers (optional)

TWIGGY

FloweR

PoWER

At the start and end sections of the letters, add tiny, twiggy V-shaped marks. If your words include the letter O, turn each one into a little flower by filling in the middle either completely or with a diamond-shaped pattern and drawing scallops around the outside of the O.

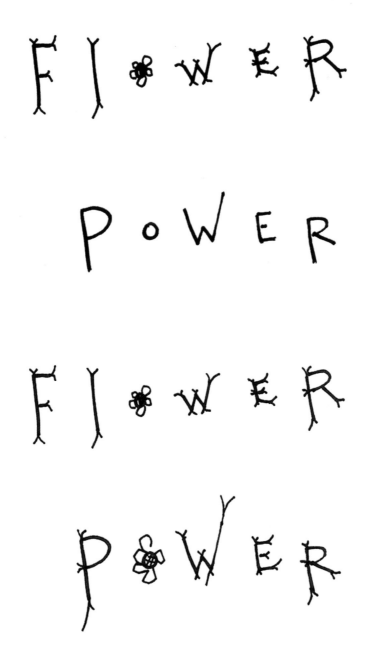

TRY IT!

Make your twiggy letters here by writing your chosen words and splitting the end sections of each letter apart. The more irregular and nonsymmetrical, the better!

WHAT YOU'LL NEED

• Black permanent marker

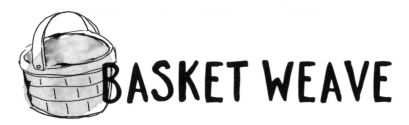

BASKET WEAVE

PROMPT: Create letters by drawing a cluster of four short parallel lines with a black fine-point permanent marker. If the first cluster was made horizontally, make the next cluster vertical and repeat this pattern until the letter is complete.

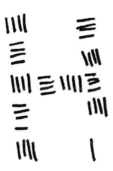

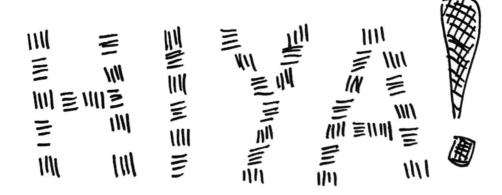

TRY IT!

Make your basket weave letters here. If the shape of a letter causes some clustered lines to be in the same direction, don't worry. A little imperfection adds character!

WHAT YOU'LL NEED

- Black fine-point permanent marker

STENCIL & STRAIGHT EDGE

PROMPT: Trace letters with a pencil and paper letter stencils. With the straight edge of one of the stencils and a black fine-point permanent marker, make diagonal lines within the penciled letter shapes. Erase the pencil marks.

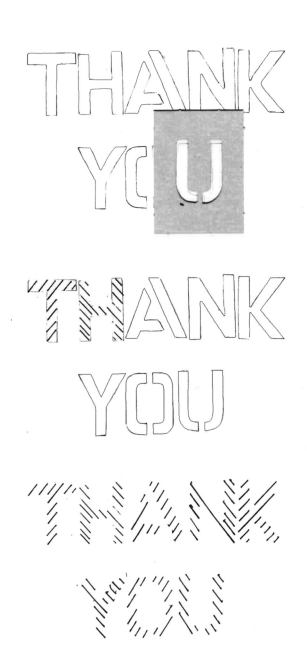

TRY IT!

Stencils come in various sizes. Use 1-inch-tall (2.5 cm) paper stencils to make medium to long words. If you have larger stencils, select a two-letter or three-letter word to practice here.

WHAT YOU'LL NEED

- Paper letter stencils
- Pencil with eraser
- Black fine-point permanent marker

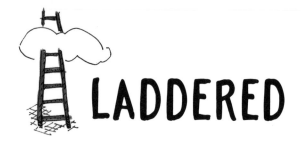

LADDERED

PROMPT: With a black fine-point permanent marker, make a ladder by drawing two vertical lines that start close together and gradually get wider at the bottom. Make a series of horizontal lines between the two vertical lines, starting from the bottom. Use this ladder as a portion of a block letter. For round letters like O, S, C, and J, get creative and make a slightly curved ladder with a rounded part of each letter.

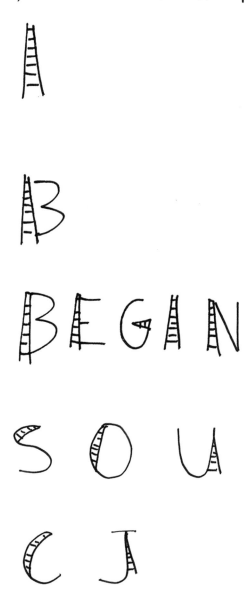

A

B

BEGAN

SOU

CJ

TRY IT!

Practice your laddered block letters here. Lowercase letters can also work well, especially if you mix some laddered letters with some that are not adorned with ladders.

WHAT YOU'LL NEED

- Black fine-point permanent marker

NEGATIVE SPACE POINTILLISM

PROMPT: Tape paper letter stencils to the page using Washi tape or artist's tape. (Unlike other tapes, these tapes can be removed without tearing the paper.) With a black permanent marker, draw letters by tracing letter stencil shapes. Remove the tape and stencils. In the spirit of pointillism, which is a painting technique that involves using tiny dots in various colors to form images, add dots of acrylic paint around the first letter using a small pointed paintbrush. Rinse the paintbrush in water and add dots of acrylic paint in a different color around the second letter. Repeat until all letters have dots of paint around them.

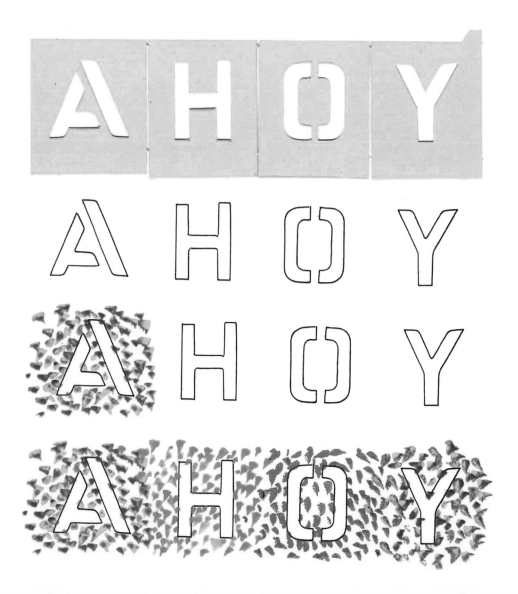

TRY IT!

Practice your letters here. Allow the paint to dry before you turn the page or close the book.

WHAT YOU'LL NEED

- Paper letter stencils
- Washi tape or artist's tape
- Black permanent marker
- Small pointed paintbrush
- Acrylic paints
- Container of water

THICK, THIN & IN-BETWEEN

PROMPT: *Trace a square using a square acrylic ruler and a black fine-point permanent marker. Create a basic block letter inside the box with a black chisel-tip permanent marker, making sure the letter touches the top and bottom of the box. Add lines or designs surrounding the block letter using markers in assorted tips and thicknesses.*

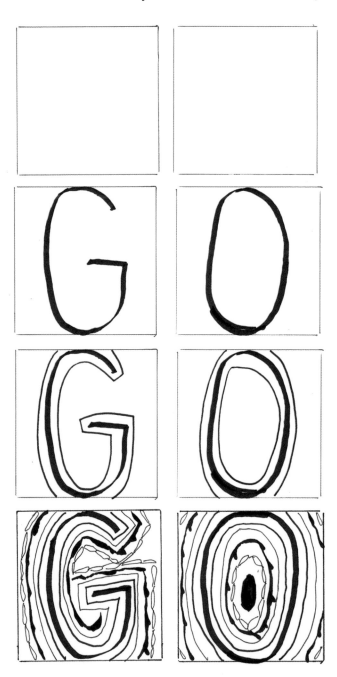

TIP

When making a line with a brush-tip pen, alternate between pressing down hard and lifting with a lighter touch to create a fun and funky thick/thin design.

THICK/THIN

WHAT YOU'LL NEED

- Square acrylic ruler (or other square-shaped template)
- Black permanent markers with assorted tips and thicknesses

TRY IT!

Here are a few boxes just for you! Practice here and then, once you get the hang of it, use these letters on posters, envelopes, and other projects.

WATERCOLOR PENCILS

PROMPT: Activate a blue watercolor pencil by dipping it in water, then write a word on the page. Let dry. Activate an orange watercolor pencil by dipping it in water, then add "shadow" accents by drawing marks next to the left portion of the blue letters.

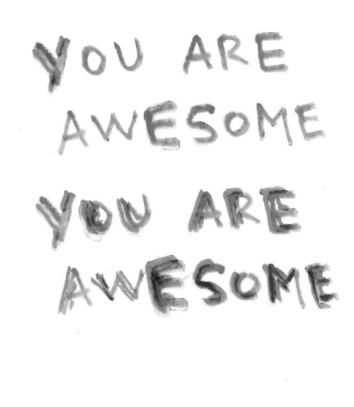

TRY IT!

Once you practice your letters with watercolor pencils here, be sure to keep the book open to these pages for a couple of minutes so the marks are nice and dry.

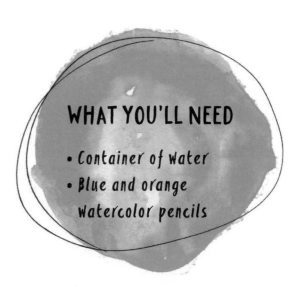

WHAT YOU'LL NEED

- Container of water
- Blue and orange watercolor pencils

ROAD SIGNS

PROMPT: With a black fine-point permanent marker, make a row of simple road signs by drawing small rounded triangles. Make another row of road signs by drawing a U shape and then connecting the tops of each U with two straight lines that form a 90-degree angle. Make a third row of signs by drawing additional small triangles. Outline all of the shapes. For the second row of shapes, add two parallel horizontal lines where the U part of the sign connects to the V part of the sign.

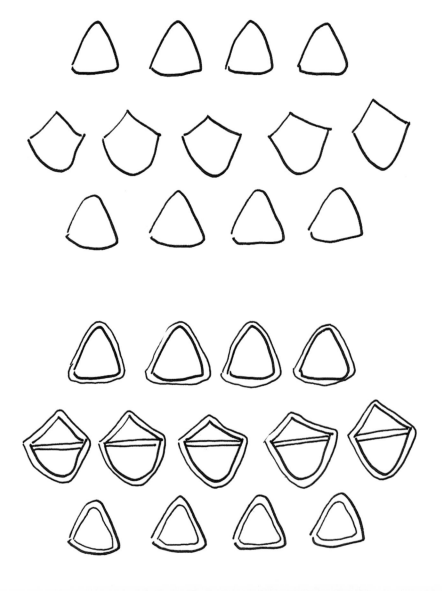

Add a touch of color to the signs with colored markers. With the black marker, write letters in the centers of each sign.

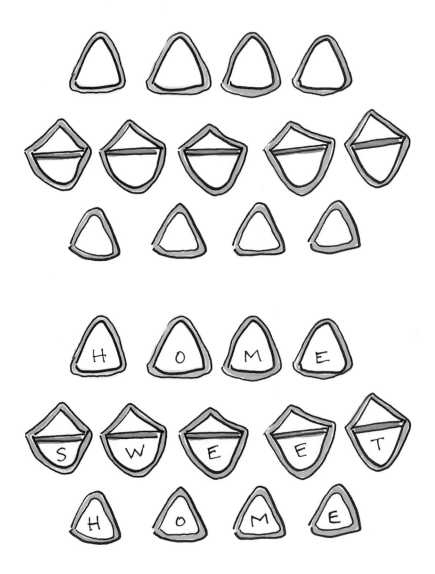

 Take a look at road signs while you travel and incorporate their designs in your next creative lettering project!

TRY IT!

Pick the text you want to put into the road signs and create them here.

WHAT YOU'LL NEED

- Black fine-point permanent marker
- Colored markers

CHECKERBOARD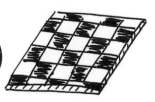

PROMPT: With a black fine-point permanent marker, create chunky uppercase letters. Make a set of horizontal lines and then a set of vertical lines in each letter. Fill in every other square space with the black marker.

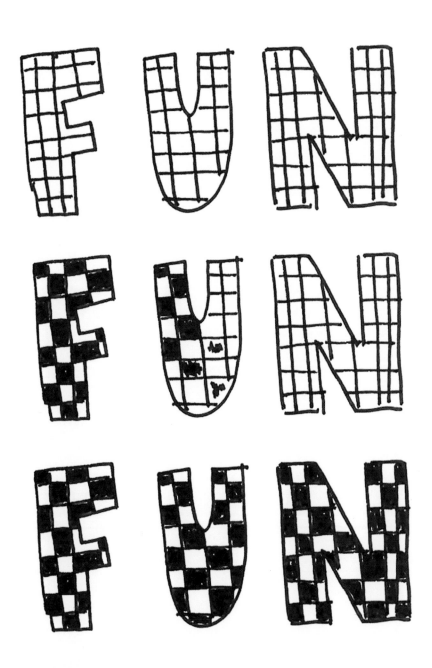

TRY IT!

Try your checkerboard letters here. Just remember that once a box is filled in, the ones on the top, bottom, and sides of that box stay blank.

WHAT YOU'LL NEED

- Black fine-point permanent marker

For a fun variation, make a set of horizontal lines at a 45-degree angle and then a set of vertical lines at a 45-degree angle. Fill in every other square space with the black marker.

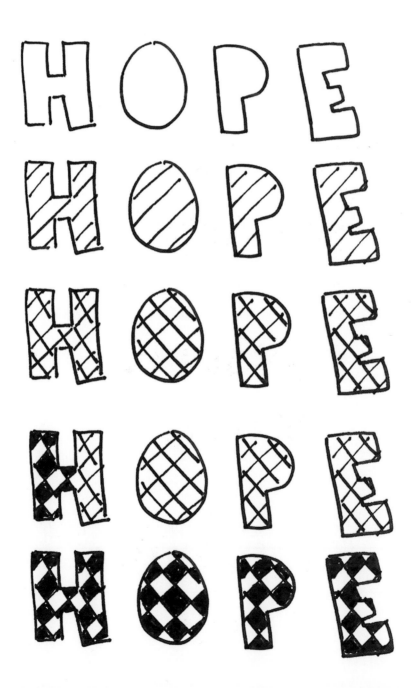

DOWNTHICK, UPTHIN

PROMPT: With a black brush-tip permanent marker, make words with lowercase cursive letters. Every time you create a downward stroke, press hard to make a thick mark. Every time you create an upward stroke, use a light hand to make a thin mark. Fill in the enclosed sections of the letters with colored markers.

a

awesome

awesome
sauce

awesome
sauce

TRY IT!

Make your thick and thin cursive letters here. And remember to be awesome.

WHAT YOU'LL NEED

- Black brush-tip permanent marker
- Colored markers

ENCASED WITH LINES

PROMPT: Make block letters with a black brush-tip permanent marker. With a black fine-point permanent marker, draw lines at a 45-degree angle all around the block letters to encase them.

TRY IT!

Start by making your letters using a brush-tip marker here. Don't worry if the letters are imperfect, as that will add personality to the work.

WHAT YOU'LL NEED

- Black brush-tip permanent marker
- Black fine-point permanent marker

Try drawing simple doodles (like a cute puppy, cat, or rabbit) with the brush-tip marker to accompany the letters.

APPLE OF MY EYE

PROMPT: Lightly sketch the shape of an apple with a pencil. With a black brush-tip permanent marker, write the names of a few apple varieties within the apple shape, using lowercase cursive. With a black fine-point permanent marker, write names of other types of apples using a combination of cursive letters, block letters, and lowercase letters. Around the circumference of the apple, write the words "You are the apple of my eye." Draw a horizon line to suggest that the apple is on a tabletop. Erase the pencil marks.

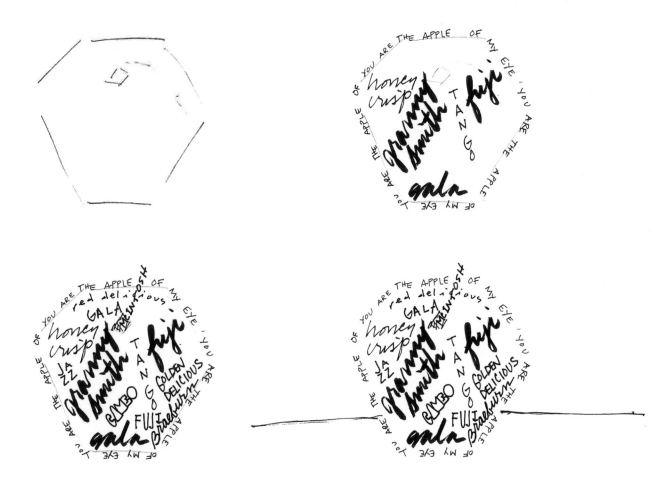

TRY IT!

Draw your apple here and fill the shape with words hand-lettered in assorted sizes and styles.

WHAT YOU'LL NEED

- Pencil
- Black brush-tip permanent marker
- Black fine-point permanent marker
- Eraser

Try drawing other simple shapes and filling each one with related words here. You can find certain items rendered in simple forms on the Internet, which you can reference to make your drawing if you'd like.

GRAINS OF RICE

PROMPT: With a black fine-point permanent marker, make letters using small shapes that suggest grains of rice. Allow some grains to be horizontal, some to be vertical, and others to be drawn at an angle. Arrange the grains to build the structure of your chosen word and then fill in the structure with as many grains as needed to complete each letter.

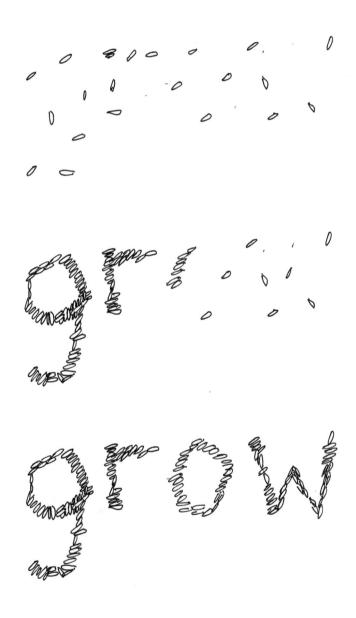

TRY IT!

Make your grains of rice twist and turn here. Fill in some of the grains with colored markers if you'd like.

WHAT YOU'LL NEED

- Black fine-point permanent marker
- Colored markers (optional)

GRADATED

PROMPT: Lightly trace letter shapes using letter stencils and a pencil. Use colored markers to make tick marks within the body of each letter. Group the tick marks close together at the bottom of the letter and spread the marks out farther as you move up the letter shapes. This will allow the letters to have a gradated effect, which means the color or shade will gradually change as you move from one area to another.

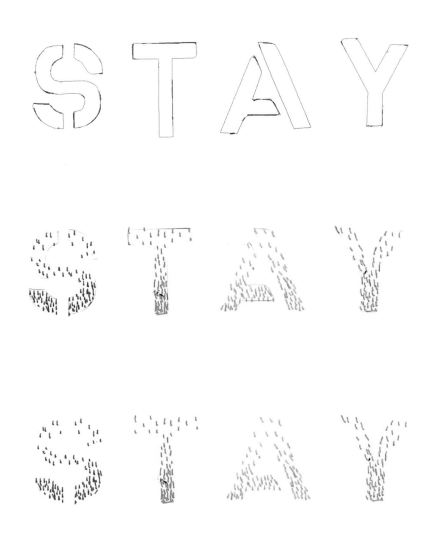

TRY IT!

Make your gradated letters here. It's okay if you don't have stencils. You can still make letter shapes with a pencil and then follow the rest of the steps.

WHAT YOU'LL NEED

- Letter stencils
- Pencil
- Colored markers
- Eraser

DRAMATICALLY STRETCHED

PROMPT: With a black fine-point permanent marker, make block letters. Fill in the letters with a black brush-tip permanent marker. With the fine-point marker, make diagonal lines that slant upward and to the right, starting from various points on the top portion of each letter. Do the same thing with the points on the bottom portion of each letter. Connect the lines from the upper and lower parts of the letter with curves and angles that sit toward the right portion of the letters.

TRY IT!

Create dramatically stretched letters of your own here. Remember that the longer the lines, the more dramatic your letters will appear.

WHAT YOU'LL NEED

- Black fine-point permanent marker
- Black brush-tip permanent marker

✳! ; PUNCTUATED

PROMPT: *Think of your favorite symbols and punctuation marks (like commas, semicolons, asterisks, etc.) and create letters with them. Start by using one symbol or mark and positioning that symbol at the start, middle, and end of a letter. Then do the same thing for the other letters using different symbols. Go back to each letter and fill the rest of the shape in with different symbols.*

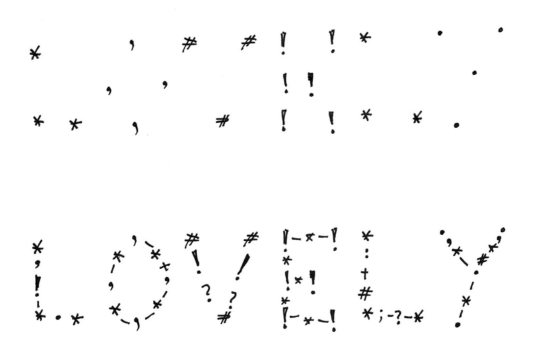

If you find it tricky to visualize letters as you space out your punctuation marks, consider lightly sketching uppercase letters with a pencil and then placing the punctuation marks on the pencil lines. Once you've finished filling in the letters with your marks, you can lightly erase the pencil lines.

TRY IT!

Make your letters with symbols and marks here. Check out your keyboard if you need ideas for all the different kinds of marks you can use.

WHAT YOU'LL NEED

- Black fine-point permanent marker
- Pencil (optional)
- Eraser (optional)

POSITIVE & NEGATIVE POLKA DOTS

PROMPT: With a black fine-point permanent marker, make two stacked words with outlined letter shapes using both uppercase and lowercase letters. For the letters in the first word, make small circles within the outlined letters and then fill those circles in with the black marker.

For the letters in the second word, make small circles and then fill in the space surrounding the circles with the black marker.

TRY IT!

Practice making letters with positive and negative polka dots here. Make some of the dots partially visible so that we only see a portion of the dot, and make some of them completely visible.

Try using different shapes like squares, triangles, and stars.

WHAT YOU'LL NEED

• Black fine-point permanent marker

BUBBLE-WRAPPED & SCALLOPED

PROMPT: On the back side of a piece of Bubble Wrap (the flat side), write chunky letters with a black thick-point permanent marker. Cut around the edge of the letters. Brush acrylic paint on the front side (the bubbly side) of the first letter and carefully press it onto the paper. Lift it off. Repeat with the remaining letters. Let dry.

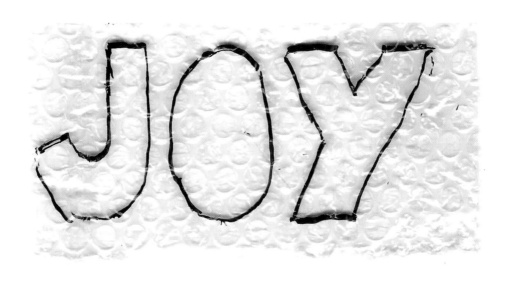

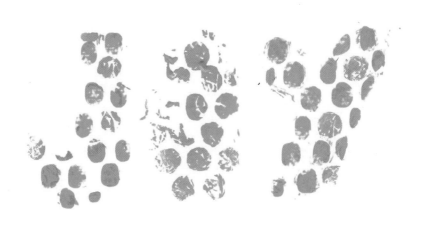

With a black fine-point permanent marker, outline the letters with lines, dots, and scallops.

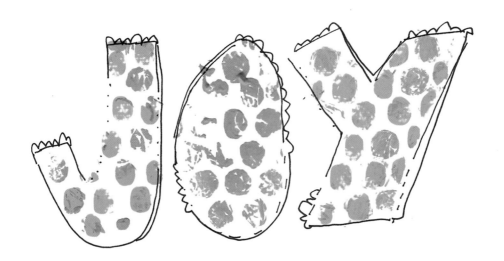

WHAT YOU'LL NEED

- Bubble Wrap
- Black thick-point permanent marker
- Scissors
- Acrylic paint
- Paintbrush
- Container of water
- Black fine-point permanent marker

TRY IT!

Don't be shy! Get beautifully messy by cutting your letters from Bubble Wrap and then making your letters here. Depending on how much paint you add to your letters, the page may wrinkle slightly. But that's okay! That just means you're really making this workbook your own. Allow the paint to dry before you turn the page or close the book.

The Bubble Wrap can be used several times. Just wipe off excess paint with a baby wipe between each use. Even if you don't completely wipe off the paint, you can apply new paint in the same or a different color and use the letters again, as long as you let the previous layer of paint dry first.

WASHI-TAPED

PROMPT: Adhere torn pieces of washi tape to the page to make letter shapes. Enjoy the letters in the simple and minimalist form seen first below . . . or create a more maximalist look by rubbing over the letters with pencil, graphite, or crayon. Dip the edge of a small piece of cardstock into acrylic paint and stamp it across the letters in a random fashion to make lines. Let dry. Carefully peel off the washi tape.

TRY IT!

Practice making a minimalist word with just washi tape here.

TIP

Washi tape comes in many different colors and patterns, which makes even the minimalist version of your letters super-exciting and fun.

WHAT YOU'LL NEED

- Washi tape
- Pencil (or graphite or crayon)
- Small scrap piece of cardstock
- Acrylic paint

TRY IT!

Try your maximalist version here by first making a word with Washi tape. Rub the letters and paint lines and then let dry before peeling off the tape. Allow the paint to dry before turning the page or closing the book.

Washi tape is secure enough to stay put during the rubbing process but can easily be peeled off. Be careful and go slow as you are peeling so you don't accidentally rip the paper.

CLOUD-SOURCED

PROMPT: *Paint a dark cloud shape with a paintbrush and black acrylic paint. Start by making an oval shape and then make certain parts of that oval protrude out, like a cloud. While still wet, add a few lighter strokes to the shape with a little bit of white paint so that the cloud has a few lighter parts but remains mostly dark. Let dry completely. With a white gel pen, draw letters into the body of the cloud. With a black fine-point permanent marker, make little dots and lines coming down from the cloud to suggest a light rain, and draw words in lowercase within the dots and lines.*

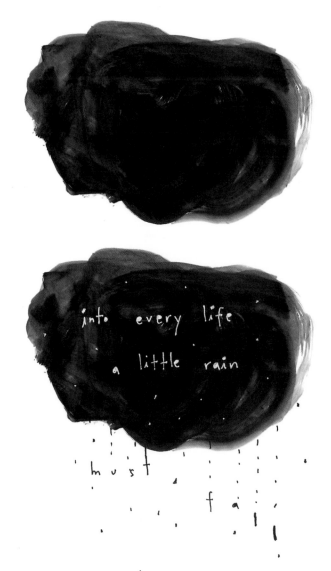

TRY IT!

Create your cloud-sourced letters here. Think about a phrase that would look good in the cloud and then a phrase that would look good "raining" from the cloud.

WHAT YOU'LL NEED

- Acrylic paint in black and white
- Paintbrush
- Container of water
- White gel pen
- Black fine-point permanent marker

STRUNG ALONG

PROMPT: Press a piece of thin string into a glue stick, making sure the string is completely covered with glue. Make letters with the glue-covered string by cutting small pieces and then adhering each piece of string to the page. Shape each piece of string into a letter and press it firmly onto the page. Let dry.

IMAGINE

TRY IT!

Practice making your string words here. Embrace the freeform look of these letters, and mix up the word by using both uppercase and lowercase letters.

WHAT YOU'LL NEED

- Thin string (such as embroidery floss, baker's twine, or sewing thread)
- Glue stick
- Scissors
- Pencil
- Paper

TRY IT!

Make another string word on a separate piece of paper, place it behind this page, and then rub it with a pencil on the front side of the page. Be sure to place the pencil on its side so that you can rub the lead without accidentally piercing the paper with the point of the pencil. (If that happens it's okay. More evidence of your lettering practice!)

BOARD GAME-INSPIRED

PROMPT: *Cut kraft paper into small rectangles and adhere them to the page with a glue stick. With a black fine-point permanent marker, draw tiny angled lines at the top-left, top-right, and bottom-right points of the rectangles. Connect these points with a horizontal line at the top and a vertical line at the right side.*

Add simple block letters with a white gel pen. Outline the gel pen marks with the black marker. Add lowercase lettering beneath the board game-inspired letters, if you'd like.

TRY IT!

Create your board game-inspired letters here. Don't have kraft paper? Then grab a brown paper bag and get to it!

WHAT YOU'LL NEED

- Kraft paper (or brown paper bag)
- Scissors
- Glue stick
- Black fine-point permanent marker
- White gel pen

 # PAINTED & CUT

PROMPT:

Abstractly paint a piece of paper with acrylic paint. Start by making some circle shapes with the first color. Fill in some of those circles with the same color. Let dry. With a second color, paint the insides of the remaining circles. Outline the first circles with this color. Let dry.

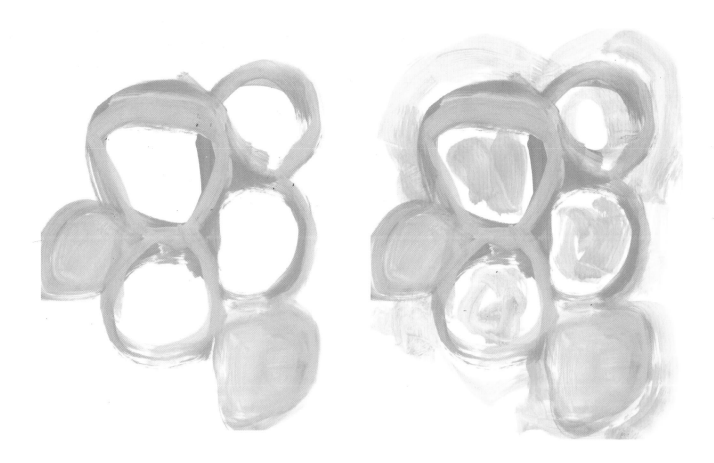

With a third color, paint more circles right on top of the first layers, filling in some of the circles with the third color. Water down a fourth color so that it has a thin and loose consistency. Load the paintbrush with the watered-down color and flick it on top of the paper to make tiny splatter marks.

Draw letter shapes onto the painted paper with a pencil and cut them out with scissors.
Attach the letters to the opposite page with a glue stick.

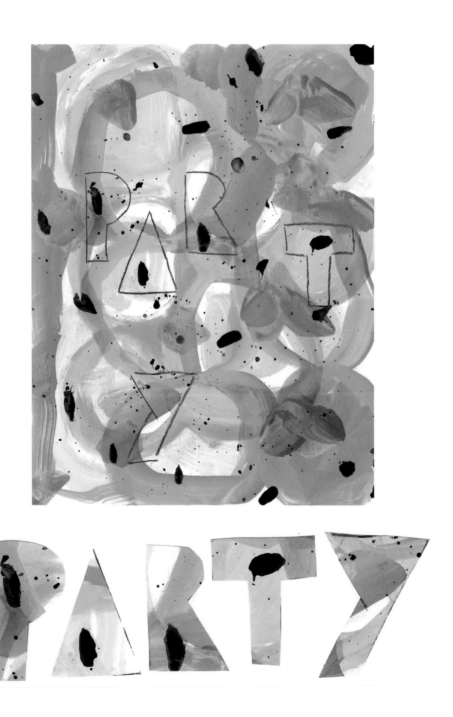

TRY IT!

Make your abstract painting on a separate piece of printer paper. After you cut the paper into letter shapes, glue them onto this page.

When cutting out the letter shapes, cut slightly inside the pencil marks so that they don't show on the final project.

WHAT YOU'LL NEED

- Paper
- Acrylic paints in assorted colors
- Paintbrush
- Container of water
- Pencil
- Scissors
- Glue stick

TRACING-WHEELED

PROMPT: A tracing wheel is a small and affordable tool found in the sewing aisle. Sewers use it to transfer markings from patterns to fabric. Creative letterers use it with paint to make letters! Dip and roll a serrated tracing wheel into acrylic paint, making sure the entire wheel is covered. Roll the wheel onto the paper, turning it in the directions you need to make your letters. Let dry.

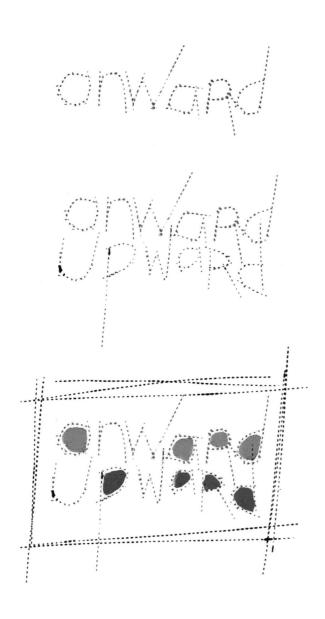

TRY IT!

Embrace the uneven nature of the letters you will create with this tool. Once you're done, make sure you wash the wheel promptly so that the paint on it does not dry.

You could also make letters with a smooth, rather than serrated, tracing wheel for a different effect.

WHAT YOU'LL NEED

- Serrated tracing wheel
- Acrylic paint

INDEX

ABOUT THE AUTHOR

Jenny Doh has authored numerous books, including *Creative Lettering*, *More Creative Lettering*, *Creative Lettering for Kids*, *Craft-a-Doodle*, *Craft-a-Doodle Deux*, *Washi Wonderful*, *Crochet Love*, *Stamp It!*, *Journal It!*, and *We Make Dolls!* She lives in Santa Ana, California, and loves to create, teach, stay fit, and play music. Visit www.crescendoh.com.

Photo Credit: Nick Holmes